# Contents

D1377799

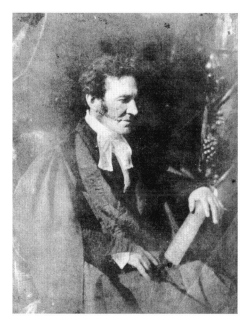

Hill and Adamson: Minister of the Scottish Free Church

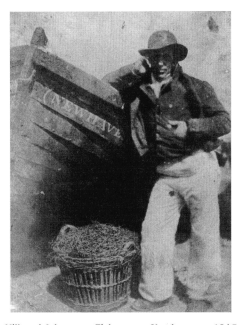

Hill and Adamson: Fisherman, Newhaven, c 1845

# You Press The Button
# We Do The Rest

*The Birth Of Snapshot Photography*

*Edited by*
*Colin Ford and Karl Steinorth*

## Dirk Nishen Publishing
### In Association with the
## National Museum of Photography
## Film and Television

Cover photograph: George Eastman (1854 - 1932) with his Kodak. This Snapshot
was taken by Fred Church, his patent-attorney, during their trans-oceanic cruise
on the S. S. Gallin (1890).

© Copyright 1988 by Dirk Nishen Publishing, 19 Doughty St, London, WC1N 2PT
© Text copyright by the authors
© Photographs copyright see page 141
Phototypesetting by ComPress, D-Berlin
Origination by O. R. T. Kirchner + Graser, D-Berlin
Printed by H. Heenemann, D-Berlin
Binding by Lüderitz & Bauer, D-Berlin
Printed in Germany. All rights reserved.

ISBN 1 85378 010 3

*You Press The Button – We Do The Rest*
*The Birth Of Snapshot Photography*

# Colin Ford
# Photography –
# A Truly Popular Medium

## In the Beginning

A century and a half ago, when the world first heard about the new art-science of photography, the honour of its invention could legitimately be claimed on both sides of the English Channel. The two processes announced in January 1839, English (invented by W. H. Fox Talbot, and using paper negatives and prints) and French (direct positives on metal, invented by L. J. M. Daguerre), were cumbersome, difficult to manipulate, expensive and slow. Only those with time and money to spare could become experienced practitioners.

It is not surprising, then, that the most successful pioneer photographers were either leisured amateurs, whose education and cultural awareness encouraged them to strive for high artistic standards, or hard-working professionals, whose short cuts through the technical difficulties enabled them to mass-produce portraits in particular.

Fox Talbot himself was a member of the landed gentry, and photography was only one of his many artistic and scientific interests. The most artistically successful practitioner of his 'calotype' process was the Scottish academic painter David Octavius Hill. Hill's results, among the earliest masterpieces in the history of the medium, depended to a great extent on the supreme technical skills of his young partner, Robert Adamson. In Edinburgh between 1843 and 1847, Hill and Adamson practised their art on church ministers, aristocrats, and the scientific and literary establishment. Only in the fishing village of Newhaven did they point their camera at working men and women, and then surely because of their picturesqueness, and the oddity of their Huguenot-inspired dress, rather than their ordinariness.

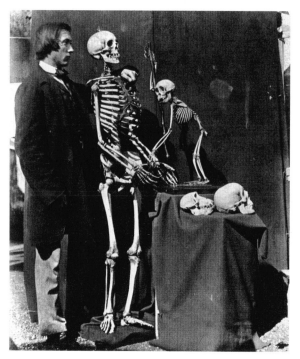

'Lewis Carroll': Reginald Southey with Skeletons, c 1858

## A Step Forward

In the 1850s, a new British process – Scott Archer's wet collodion – used glass negatives to produce finely-detailed paper prints. Wet collodion soon replaced both calotype and daguerreotype, though it still demanded a lot of time and care. It attracted many to take up photography as a hobby, but they still had to be comparatively well-off. The unmarried Oxford don, 'Lewis Carroll'; the wife of a successful Indian administrator and coffee planter, Julia Margaret Cameron; titled ladies such as Lady Jocelyn and Lady Hawarden: these were the natural amateur exponents of wet collodion photography. Even the royal family fell under the spell: Queen Victoria and Prince Albert collected photographs assiduously, had a darkroom built at Windsor Castle, and probably took photographs themselves.

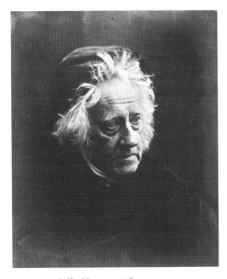

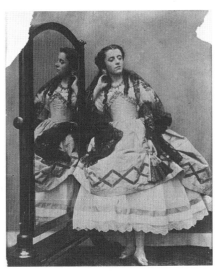

Julia Margaret Cameron:
Sir John Herschel, 1867

Lady Hawarden: Isabella Grace
Maude Hawarden, c 1862

The majority of professional photographers were portrait-ists in High Street studios, ensuring commercial success by making flattering images of their sitters. To keep the exposure time of the slow collodion-based materials as short as possible, they worked in 'glasshouses', where they could pour light onto the sitters from every direction. Even so, their victims had to keep motionless for seconds, even minutes, on end. The overall light flattened features and smoothed out character; the need to keep still ruled out relaxation, the photographer's quest for profit meant that he spent as little time on each sitter as possible. The resulting portraits were stereotyped, characterless, and gloomy.

The Dream of the Snapshot

All this began to change during the 1880s, as cameras improved in speed (the reduction in the time needed to get a satisfactory exposure), mobility and lightness: speed was

perhaps the most important. George Washington Wilson had been able to take what he called 'quick' pictures, with exposures of only about a tenth of second, as early as 1860, and in the same year the eminent Victorian astronomer and scientist, Sir John Herschel, wrote:

*What I have to propose may appear a dream. It is ... the possibility of taking a photograph, as it were, by a snapshot – of securing a picture in a tenth of second of time.*

Herschel made significant contributions to the early development of photography. It was he who had discovered sodium hyposulphite ('hypo', the fixer which was essential for developing and printing), and had coined the words 'negative' and 'positive' in their photographic connotations. As far as we know, his use of 'snapshot' in this context was also the first. His dream of the snapshot became almost reality in the 1870s with the invention of the dry plate, soon widely available. The famous 'Ilford' plate, introduced in 1879, became in the 1880s the best-selling photographic plate in the world.

Dry plates enabled Eadweard Muybridge, an Englishman at the University of Pennsylvania, to make many studies of movement, especially of human beings and animals. In France, Etienne Marey, inspired by meeting Muybridge on a lecture tour in Paris, invented his *fusil photographique* ('photographic gun'), in which he mounted tiny glass plates in a disc to facilitate quick changing.

When the dry plate was replaced by lighter and more flexible film, Marey could speed up still further, recording the wing movements of birds in flight. His new apparatus, the Chronophotographe, was virtually the world's first moving picture camera and, had he been a businessman or an entertainer rather than a scientist, he might now be recognized as the inventor of cinema. But that had to wait for another ten years and the most significant photographic invention of the 1880s was that of the American George Eastman. His Kodak camera – easy to carry and operate, freed of the hitherto inhibiting tripod – at last enabled photography to capture moments of unposed reality. From now on, the world had to be ready to be photographed unawares.

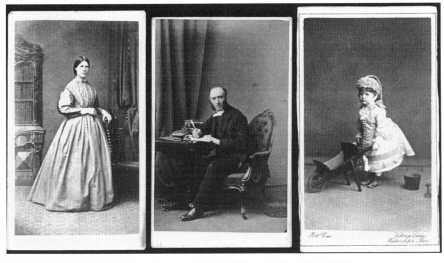

Three anonymous carte-de-visite portraits of the 1860s

## Popular Photography

From the 1888 invention of the Kodak, photography had also to abandon its status as an art form. From the very beginning, when the French painter Eugène Delacroix had looked at a daguerreotype and exclaimed: 'From today, painting is dead', artists, critics and connoisseurs had willingly accepted photographs as works of art. After the invention of the Kodak, however, this changed. If all one had to do was – literally – 'press the button', and photographs could be taken by any man, woman or child, the results could hardly be works of art.

In just fifty years, photography had run the gamut from scientific wonder to lucrative profession, from respected art form to widespread hobby. From now on, it was to be of as much interest – or more – to the social historians as to the historian of science, technology or art.

## The National Museum of Photography, Film and Television

It is the social significance of photography which informs much of the National Museum of Photography and especially of its Kodak Museum, telling the story of popular photography. We believe that, throughout the last century, photography has played an increasing role in people's lives, recording their work and leisure, showing them what the world is like, and expanding their vision. It is this exploration of the place where photography touches every human being's existence which has made the Museum so popular, with an audience that comes to be amused, excited, entertained and educated by a medium with which they have daily contact – from the newspapers at breakfast time to the television every evening. It is, we like to think, a museum for everybody who has taken a photograph, been photographed, been to a movie theatre, or watched television.

It is this which makes 1888, the year the Kodak came into being, worth remembering for more than the birth of snapshot photography. It is the moment when photography came of age, ready to play its part on a far more important world stage than the art gallery or the portrait studio.

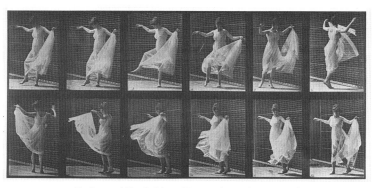

Eadweard Muybridge: Woman in Motion, c 1884

From the Kodak-Primer, the first advertising pamphlet for the new camera (1888)

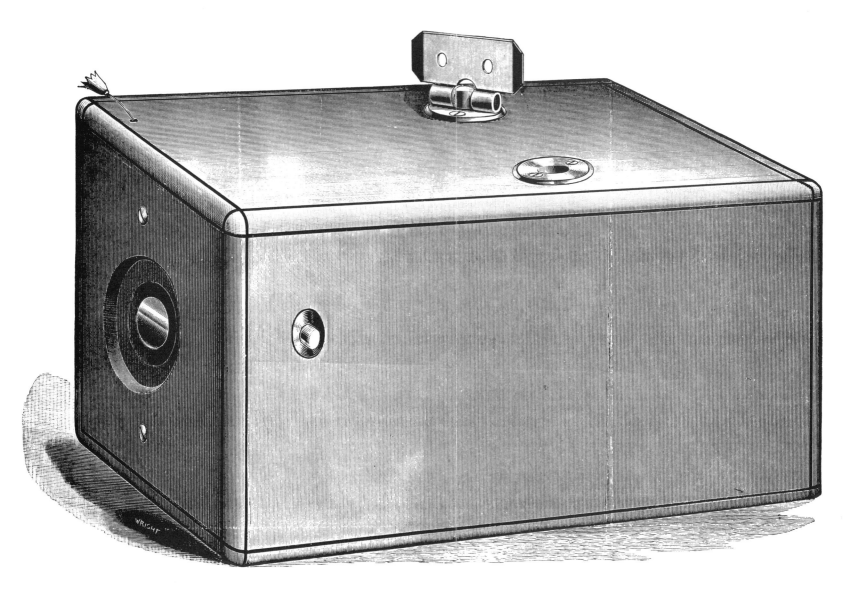

FULL SIZE.

# Karl Steinorth
# Photography for Everyone

## The Beginning of Snapshot Photography

The year was 1839, when the French Academy of Sciences officially announced the birth of photography. This new way of permanently capturing a fleeting moment was greeted with enthusiastic interest around the world, and it quickly became the delight of a century. During the first forty years of its existence, however, photography was a very complicated and expensive undertaking. In spite of many improvements in its details, its practice remained the privilege of the few who were able to master the considerable complexities of photographic technology.

Young American bank employee George Eastman from Rochester, New York, was among those who, in 1877, came to grips with the problems of manipulating a camera. He had been conscientiously saving his money for a long time in order to take an extended vacation trip. His intended destination was the island of Santo Domingo, which was much in the minds of Americans in those days because President Grant wanted to buy its Samana Bay as a base for the American navy. Eastman talked about his travel plans with a colleague who had once worked as an assistant to the photographer of the Powell surveying expedition. His friend suggested that he take a photographic outfit along on his trip, so that he might document his experiences with photographs. Eastman accepted the suggestion, a decision that was to shape the rest of his life.

The photographic process that George Eastman had to learn as a photographic beginner was the wet collodion

process on glass plates. Described by Frederic Scott Archer in the March 1851 issue of The Chemist, its shorter exposure times had made all earlier processes virtually obsolete. This process involved coating collodium, which contained potassium iodide, on a glass plate and tipping it until a layer of even thickness was achieved. The plate was immediately sensitized with a solution of silver nitrate. It had to be exposed immediately, while still wet. Since all these steps had to be executed right on the spot, the photographer who wanted to take pictures outdoors had to lug not only the heavy glass plates along, but also the complete paraphernalia for coating those plates, in addition to a complete darkroom outfit. George Eastman later described his difficulties in working with the new collodium process in the following way.

'But in those days, one did not "take" a camera; one accompanied the outfit of which the camera was only a part,' Eastman recalled. 'I bought an outfit and learned that it took not only a strong but also a dauntless man to be an outdoor photographer. My layout, which included only the essentials, had in it a camera about the size of a soap box, a tripod, which was strong and heavy enough to support a bungalow, a big plate holder, a dark tent, a nitrate bath, and a container for water. The glass plates were not, as now, in the holder ready for use; they were what is known as 'wet plates' – that is, glass which had to be coated with collodion and then sensitized with nitrate of silver in the field just before exposure. Hence this nitrate of silver was something that always had to go along and it was perhaps the most awkward companion imaginable on a journey. Being corrosive, the container had to be of glass and the cover tight – for silver nitrate is not a liquid to get intimate with. The first time that I took a silver bath away with me, I wrapped it with exceeding great care and put it in my trunk. The cover leaked, the nitrate got out, and stained most of my clothing.

Outdoor photography itself in those days was a major fastidious and unnerving procedure. For one thing, the darkroom tent had to be set up as close as possible to the camera position, and the plates had to be coated and sensitized just

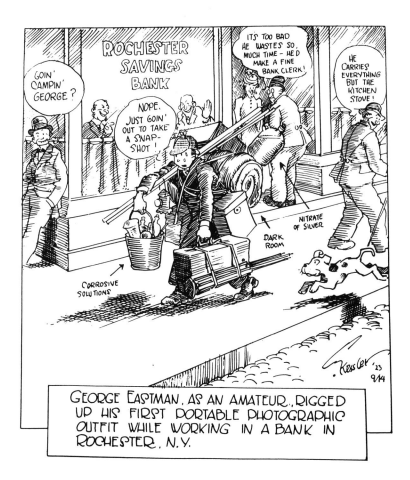

GEORGE EASTMAN, AS AN AMATEUR, RIGGED UP HIS FIRST PORTABLE PHOTOGRAPHIC OUTFIT WHILE WORKING IN A BANK IN ROCHESTER, N.Y.

before exposure. That was not only a tiring and bothersome operation, it also required considerable dexterity. To tell the truth, I was not able to do anything with my outfit until I had taken lessons from a professional photographer for 5 dollars. All related information was of quite a theoretical nature. The chemical reactions of the silver nitrate were complicated, and sometimes the coated plates did not want to work at all, which could be quite surprising and very frustrating. The entire procedure was complex and cumbersome, and also very costly.'

In spite of all its problems, photography continued to fascinate George Eastman. He began to think that there must be a way to make it easier and handier. Eastman, who had no scientific education at all, began to read everything he could find about photography.

His first hopes for simplifying photography came with reports from England and France: the so-called dry plate, created in 1871 by London physician Richard Leach Maddox, was said to be on its way to becoming a practical product. Eastman realized that a dry plate, coated and sensitized in advance, and inserted in the holder in the comfort of a home darkroom, could be brought home for processing after being

used for picture-taking in the field. If a dry plate could be produced that worked reliably, the darkroom tent, coating, sensitizing, and developing in the field would all become unnecessary. And all that baggage of breakable, heavy, and hard-to-handle components would be eliminated. In short, the dry plate would make the use of a camera away from the studio much, much easier. Eastman decided to investigate the matter of dry plates much more closely. He used his savings to buy chemicals and began to experiment in his mother's kitchen.

George knew the general directions from numerous reports and suggestions published in British and French photographic magazines: he coated a clean glass plate with a thin layer of gelatine in which he had suspended some silver salts. But actual production of a usable dry plate was quite complicated. Even trained scientists and technicians were frequently stumped by this endeavor. Eastman was neither

one nor the other, but he was inquisitive and methodical, and resolved not to quit after the first attempts. It was during those efforts, which consumed all his free time and many a night, that he read about a special formula for a dry plate published by London hatmaker and devoted photographer Charles Bennett in the issue of March 29, 1878 of the British Journal of Photography. Eastman studied that article again and again, made some changes based on his experiments and experiences, and finally came up with a usable dry plate.

At first he made dry plates only for himself and for a very few photographers in and around Rochester. In England there were already several companies, such as Mawson and Swan, which manufactured dry plates on a production basis. These plates had a sufficiently long life span to be shipped to the USA and distributed by the photographic dealers that were already in existence in those days. This gave Eastman the idea to start regular production of dry plates himself. But mass production of dry plates required a considerable investment in mechanical equipment – a machine with which one could coat a dozen or a hundred dozen plates with equal quality and uniformity. George Eastman designed and built just such a machine. Then he did something unusual: he withdrew 400 dollars from his savings account and travelled to England, the center of photography at that time, in order to apply for a patent for his emulsion coating machine (which was granted on July 22nd, 1877). Eastman believed that no one who knew his machine would dream of ever again coating photographic plates manually.

Back in the U.S., he continued his experiments with film emulsions, developed an improved emulsion coating machine (which he patented in the U.S.), and made his first contact with the E. & H. T. Anthony Company, then the most important photographic dealer in New York. The great moment came in November of 1880, exactly three years after his first encounter with photography: The third floor of a house in the center of Rochester was rented as a production site, a business partner was located, packing materials were ready, labels and instructions for future customers were

printed. Production began at the newly founded Eastman Dry Plate Company – George Eastman was in business. The company found a receptive market. His dry plates were generally distributed by the E. & H. T. Anthony Company, but the reputation of his plates spread so fast that other dealers began to place orders for them.

Everything looked very promising, when suddenly customers' complaints began to increase. The plates were defective. Eastman recalled as many shipments as he could find, and he offered to replace every plate that was unsatisfactory. He then stopped production in order to begin a long series of experiments. But the formula that had been his standard recipe continued to fail. Eastman could think of only one solution for this emergency: a trip to England. Somebody there would certainly be able to help him find an explanation for his problems. And once again, London proved to be a place for answers, because Eastman learned enough there to conclude that his problems were not due to his formula nor to his manufacturing process. Instead, they stemmed from the gelatine, which had quite naturally been ignored, since it merely served as a passive vehicle for light-sensitive silver salts.

Eastman returned to Rochester, acquired a different gelatine of higher quality and went to work. Tests very quickly returned to steady positive levels. When other experiments also showed repeatable good results, Eastman resumed his shipments. A very significant step was his immediate decision henceforth to test all incoming raw materials thoroughly. And it was in the nick of time, because he was beginning to run short of funds. He had to take out a short term loan of 600 dollars. After his setback had been overcome and when his dry plate business was running well again, Eastman once again had time to think about how picture-taking might be made even easier. One of the big difficulties was still the handling of the heavy, large and breakable glass plate. A quantity of plates could make a tourist's luggage so heavy that he could no longer carry it. Eastman therefore began experimenting with lighter support mate-

rials. At first he considered paper: paper could be rolled, photographic emulsions adhered reasonably well to paper, paper was lightweight and relatively cheap. The main problem with paper as a film support base was that it was not completely transparent. Even though it could be made nearly transparent by the application of oil, glycerine and other substances, the texture of paper could never be completely eliminated, so that prints did not look sharp and grainless. Nevertheless, the advantages of paper caused Eastman to use it as a negative support material for the present.

But first he had to design a mechanism to transport roll paper through the camera and keep it flat and in position during the exposure. He developed such a device with William H. Walker, one of his employees – the Eastman-Walker Roll Holder. After removing the ground glass plate, this roll film cassette, as we would call it today, could be inserted in the slot on the back of the camera, where one would normally insert a plate holder. The Eastman-Walker Roll Holder was an immediate success. Many photographers were delighted to be able to make a large number of exposures so conveniently. No more heavy glass plates, no more worries that irreplaceable negatives might be broken, causing much grief to the photographer. Even though the paper negatives more or less clearly showed the structure of the paper, photographers accepted that drawback, because a discreet appearance of structure could be used for 'artistic' purposes.

But Eastman was not yet satisfied with such a roll of paper coated with a light-sensitive emulsion. To do away with these inconveniences, he developed his 'American Film'. It, too, was based on roll paper which, like its predecessor, was also coated exposed and processed. But once the paper negative had been fixed, its thin, easily damaged emulsion layer was transferred to a transparent sheet of gelatine.

It was a difficult procedure, but it led to excellent results. But even with American Film and the roll holder, photography still was not uncomplicated. Most cameras were still bulky and cumbersome. Above all, developing and print-making still had to be performed by the photographer him-

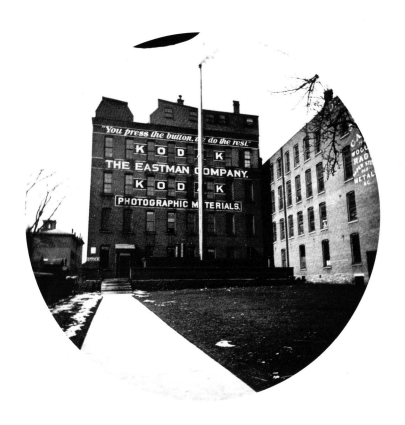

The Kodak factory in Rochester. The peculiar structures on the roof hold the first picture factory of the world. The photograph on page 25 shows the interior.

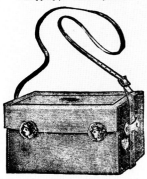

self, and this required skills and accessories not available to everyone.

George Eastman achieved the breakthrough with a camera that he introduced in the autumn of 1888. This camera had the shape of a small cigar box: $3\,^3/_4$" high, $3\,^1/_8$" wide, and $16\,^1/_2$" long, thus easy to hold with one hand. Its built-in roll holder was loaded with enough film for one hundred circular pictures $3\,^1/_2$" in diameter. A cylindrical shutter was cocked by pulling a string and released by pressing a button. The film was advanced by turning a key. A revolving indicator showed when enough film had been wound.

Eastman needed a name for his new creation, a name that did not mean anything specific in any language, a name that was simple, easy to use and easy to remember. Because he liked the crisp, clear sound of the letter K, Eastman began toying with anagrams and combinations of letters beginning and ending with the letter K, or both. Eventually, the word 'Kodak' emerged. Eastman promoted his 'Kodak' concept with a small booklet called the 'Kodak Primer', as follows:

'Can anyone who is in his right mind dispute the fact that the need to perform ten different actions, where an error in any one of them can ruin the entire job, takes all the fun out of what could otherwise be an enjoyable occupation? The prin-ciple of the Kodak System is the separation of actions that every photographer can handle, and work that only a profes-sional can perform. We can supply anyone – man, woman or child – who has enough skill to point a box straight at the sub-ject and to push a button . . . with a device that makes the prac-tice of photography independent of special technical skills. It can be used without prior experience, without darkroom and without chemicals.'

The separation of the taking of the picture from all the technical work which was then executed 'industrially', was the heart of Eastman's new system. To provide everyone with the opportunity of making photographs, Eastman, who was a pioneer in this field, created a developing and printing service. When the camera owner had completed his hundred exposures, the camera was returned to Eastman's factory.

There, the exposed film was removed and a new one loaded in the camera, which was then immediately returned to the customer. The negatives were developed and sent to the customer together with the mounted prints in about ten days.

The first pictures that the Kodak factory returned to its customers had a peculiarity: all of them had round images. The reason was simple: the inexpensive wide angle lens had poor resolution on the outer parts of the image, and Eastman solved this problem by installing a round mask in the camera. Since the first three models of this camera were equipped with such a mask, and since these models were only manufactured until 1892, except for the slightly larger model, which was made until 1896, round pictures are very easy to date.

Even before the Kodak camera was introduced, Eastman was convinced that film on a paper base could only be a temporary solution. His objective was to come up with a transparent base that would eliminate the need to strip the emulsion from the paper base. But all his own experiments in this direction were unsuccessful. This motivated Eastman to hire a young chemist by the name of Henry M. Reichenbach, whose task it was to continue that research. While Reichenbach searched for a chemical composition that would serve as a transparent emulsion support, Eastman concentrated on the manufacturing technology for such a product. After many trials, Reichenbach finally found the recipe for a film of nitrocellulose that had the desired features. In 1889, the lawyers had completed the texts for the patent applications. These covered both the formula for the nitrocellulose solution as well as the film making machine designed by Eastman himself. Thus began a new phase in film technology.

Nevertheless, before snapshot photography could really become common practice, two disadvantages would have to be eliminated: the need for completing 100 pictures before the film was ready to be returned to the factory could easily cause a loss of interest. Thus an easier way of loading the camera was needed in order to enable the photographer to

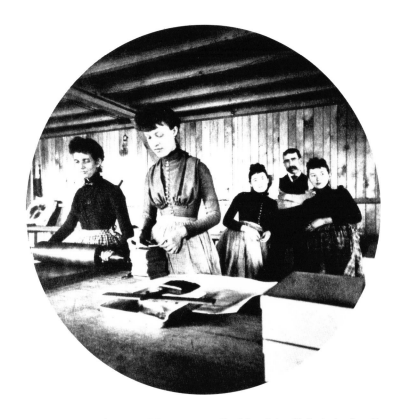

Women workers of the Kodak factory move the thin prints with the help of a roller on cardboard.

cover his requirements with shorter films. This problem was solved in 1892 by the introduction of a daylight-loading roll film designed for only twelve exposures. The costs, however, were still too high. The price of 25 dollars for the first Kodak camera was rather high, and this caused Eastman to seek other ways to bring down the cost of snapshot photography even further.

With that in mind, Eastman instructed his camera designer Frank Brownell to develop a simple camera that could be manufactured inexpensively through mass production. The result was a box camera that came on the market in February 1900. It was given the name 'Brownie Camera', after the popular Brownie cartoon characters created by Canadian artist and author Palmer Cox. Through his books and through the Brownie cartoon stories printed in childrens' magazines, these characters were as familiar in American households then as Mickey Mouse is today. The new camera designed by Eastman was a success: all one had to do was to take the picture; everything else was handled by Kodak.

The Brownie camera with its sensational price of only one dollar became a worldwide success. During the first year alone, more than 100,000 were sold, half of them in Europe. Many other photographic companies brought forth similar cameras, following the lead that Eastman had created with his simple cameras.

*Snapshot*, this is a word from hunters' jargon. During the late 1850s, it began to acquire a photographic meaning, when the first short exposures were made. Sir John Herschel used the term snapshot in 1860 for a rapid sequence of short exposures of motion studies. But it was only in the 1880s, when short exposures began to be more common, that the term became accepted in common usage. The word became

increasingly associated with photographs made by amateurs with simple cameras.

At that time, most snapshots were being made with the new Kodak. Pictures taken with that camera very clearly show the more casual and direct attitude towards photography exhibited by snapshooters (as professional and artistic photographers liked to refer mockingly to users of a Kodak camera), which later influenced photography in general. The new camera stimulated people to start taking pictures without any prior training, many of them taken during a normal day. The new photographer was free of the encumbrances and limitations of the professional photographer. They had fewer preconceived notions about photography. They were free from the limitations of tripod-mounted cameras in choosing their viewpoints and angles. Their very lack of technical expertise allowed them to approach photography under circumstances and conditions professionals would have considered inappropriate. In the process, they made many mediocre pictures, but they also made many impressive pictorial records. What characterizes the early snapshots as well as those of today is that informal atmosphere, familiar surroundings and familiar company are conducive to more relaxed poses and more natural bearing and expressions. In addition there is the natural tendency to fool around in front of a camera when it is in the hands of friends and relatives.

In thumbing through old family albums, it is surprising to discover that the subjects of snapshots have changed very little with the passing of time. In spite of technical advances, today's snapshooters are generally interested in the very same subjects that interested their predecessors of a hundred years ago. Thus snapshots show a continuing repetition of ever recurring subjects within which, however, a remarkable variety is possible. Most snapshots can easily be classified in one of the following categories: people, leisure time activities, beach life and vacations, the city, traffic, people at work. LIFE magazine described this as follows in its story on the American family album:

'No two family albums are identical, yet somehow they are all alike. The events recorded by the pictures in an album can generally be predicted: marriages, graduations, the new baby, and the pride with which we show off our new car or a loved pet.'

Arthur Goldsmith recently wrote something very similar: 'Eastman was right. Today snapshots are still mostly records of personal events, just as they were in the beginning of photography. Snapshots are made mostly during vacations, holidays and trips, and other important events, and they are usually prized more as visual souvenirs than they are as aesthetic images. Snapshots in general are relevant because they show the same events in the lives of people in endless repetition, but also because they are highly personal documents.'

In spite of (and because of) their uncomplicated creation, many snapshots also have an historic significance, which is increasingly being recognized, especially in modern times. Through the pictures taken by generations of unknown, unsung snapshot photographers, it is possible for us to observe in retrospect the less formal private aspects of daily life of the last hundred years far more than through any other photographic material. How much we owe to the snapshot for giving us a unique insight into the world of our fathers was proven dramatically by the exhibition by Brian Coe and Paul Gates entitled 'Snapshots'. In the catalog for this exhibition, the authors compare the information that today can be gleaned from snapshots with information that can be found in photographs made by professional and amateur photographers:

'The snapshot, made spontaneously, without forcing the subject, and without waiting for ideal conditions, is more satisfactory for the needs of the historian. There are, for instance, many portrait photographs taken by wellknown as well as lesser known professional photographers. But these portraits have only limited value as period documents. While they have given us a meticulous description of the clothes

and fashions of their times, while they also showed us how their models looked when they sought to make an impression with their wealth, their dignity and their beauty, still they only showed us how they looked, not how they were.'

Coe and Gates also see the snapshot as more revealing historically when compared with photographs made by serious amateurs who have dedicated themselves to the art of photography.

'The early enthusiastic amateur was preoccupied, as many still are today, with the production of exhibition or "salon" pictures. He aspired to create formalised "camera studies", beautiful enough in their own way, but more concerned with evading contemporary reality than with portraying it ... The "creative" techniques by which compositions were "elevated" – choice of lighting, angle and point of view, the manipulation of the camera and of the print in the darkroom – will frequently invalidate the picture as an historic record ... The snapshot provides, for the first time, a glimpse of how ordinary people of the late nineteenth century onwards lived, and records this with a factual accuracy and clarity which only photography can achieve. We see people at work and at play, on holiday or in the office; we see their houses, both inside and out. We can study the suburban garden and see the backyard as well as the front of the house. We can observe all those telling details which would not have been thought worthy of a picture in themselves.'

For many years, snapshot photography served as the target for ridicule by serious amateurs and professional photographers. Many do not consider a snapshot worthy of serious viewing. The subject of snapshooters was an unending source of humorous inspiration for caricaturists and comics. Even so, there were very early defenders who believed that snapshots could have aesthetic qualities. Alfred Stieglitz, for instance, complained that 'now, with the aid of the Kodak camera, every Tom, Dick and Harry could effortlessly learn how to capture an image on a light-sensitive plate, which is something that the public apparently wanted – no work, but a lot of fun'.

On the other hand, Stieglitz strongly recommended the use of such cameras for 'serious' photographs. Amateurs should take such cameras into the streets, in spite of or because of bad weather, and they should not worry about technical perfection, because microscopic sharpness in itself is of no pictorial value. The small unsharpness of a moving subject would often help to convey the impression of action and movement. Some of Stieglitz' most famous photographs are in a real sense snapshots, even though they are the results of artistic input. What snapshots by master photographers can tell about an era and about the spirit of the times was shown more eloquently by Jacques-Henri Lartigue than by anyone else.

Nevertheless, the most important aspect of snapshot photography today is still – one hundred years after its invention – that people want from it nothing more than simple and spontaneous personal records of people, events and places, and that the many millions of pictures taken every year should bring their creators fun and satisfaction. No wonder, then, that the news of George Eastman and his snapshot photography spread around the world like wildfire, and that the small Kodak box became increasingly popular, so much so that the Kodak laboratory had difficulty in finishing all the films it received in the allotted time. A report in the October 1889 issue of Wilson's Photographic Magazine stated that between sixty and seventy Kodak cameras were received every day, so that 6000 to 7000 negatives had to be developed every day and prints had to be made from these negatives. The number of cameras rose significantly after important events and holidays. George Eastman's idea of a photographic system that would permit anyone to make good pictures was a great success.

The importance of snapshot photography to all of us was recently summarized by the famous LIFE magazine: 'When a house catches fire, the first thing that many people try to save is their family album. Because the snapshots that are preserved in that album are windows that permit us to look back at moments we love to remember. Snapshots are – regard-

less of how unsharp, over-exposed or yellowed they may be – an inseparable part of ourselves. As we look at those old pictures, we see how everything looked in those days, and what emotions we were feeling at that time.'

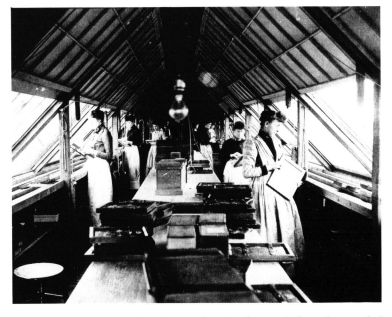

The prints were produced with the help of copying frames. Delivery times varied according to the weather.

# You Press The Button...

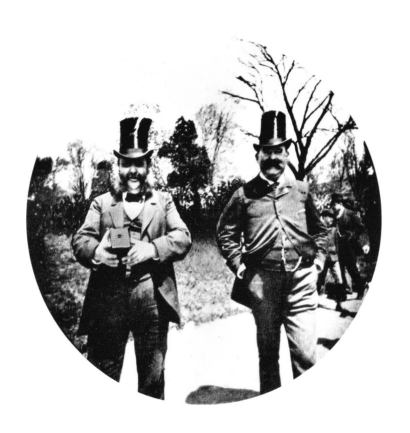

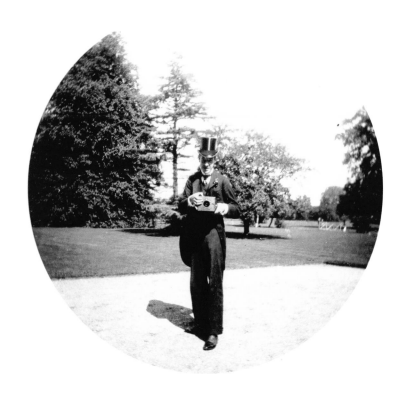

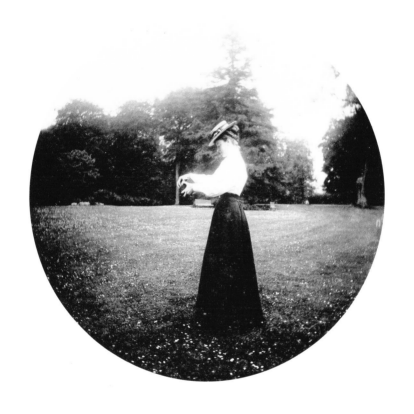

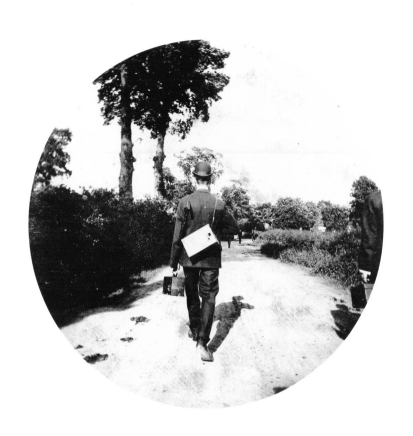

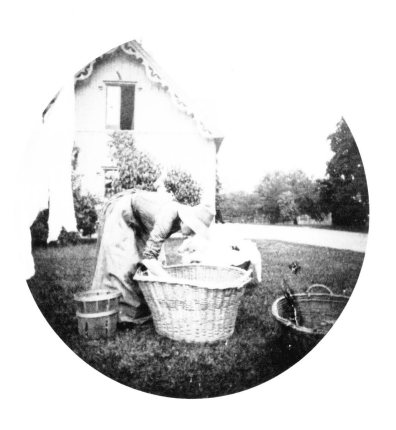

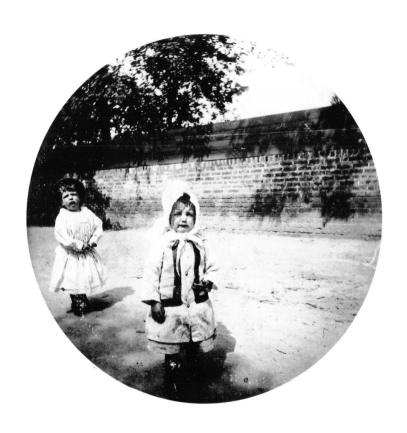

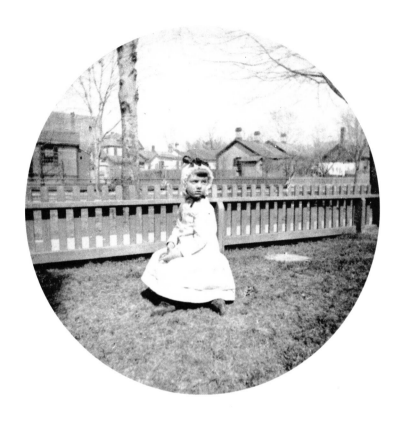

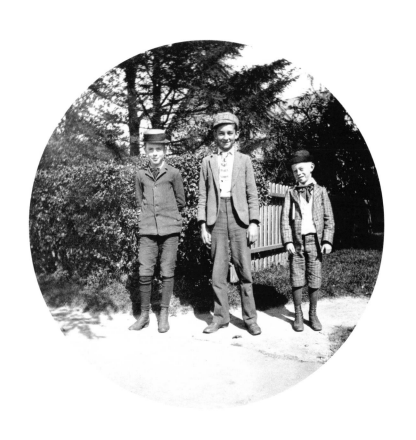

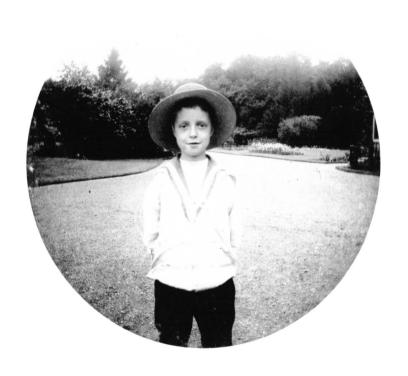

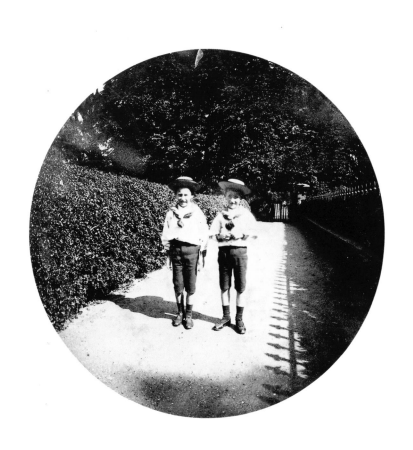

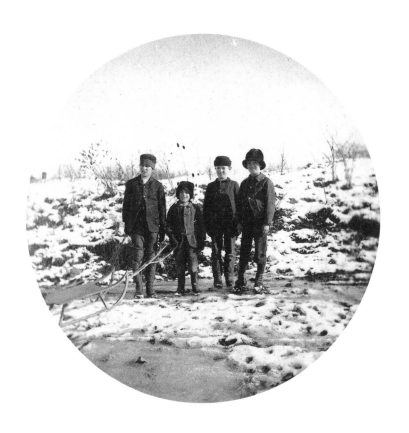

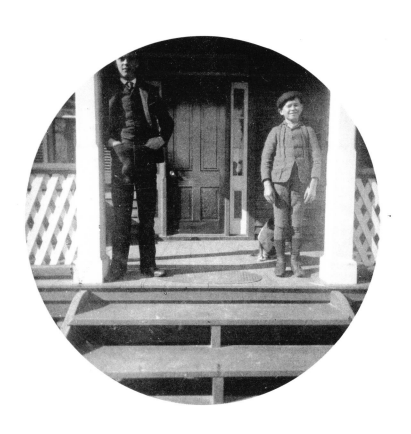

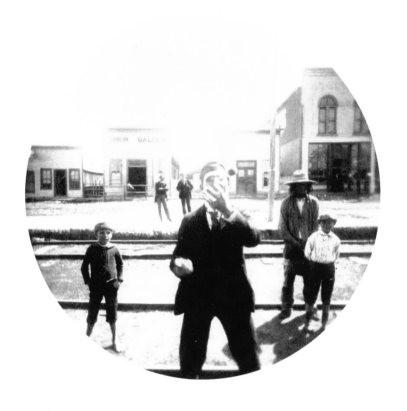

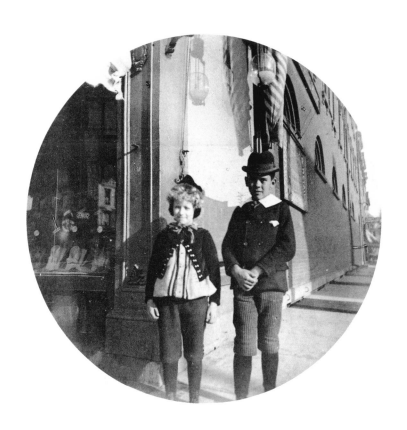

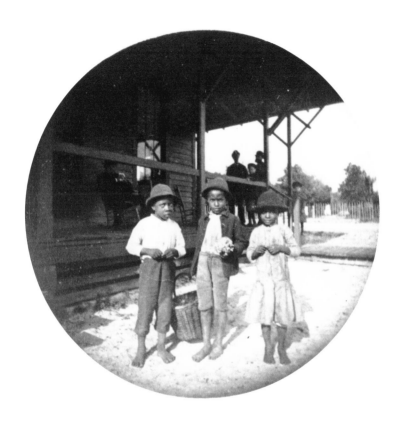

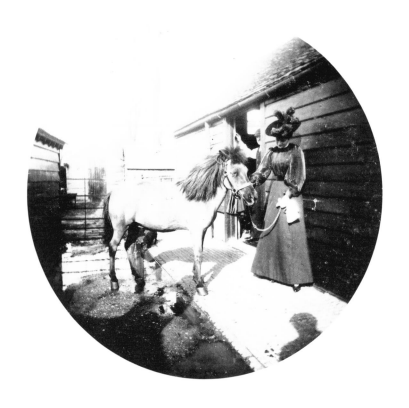

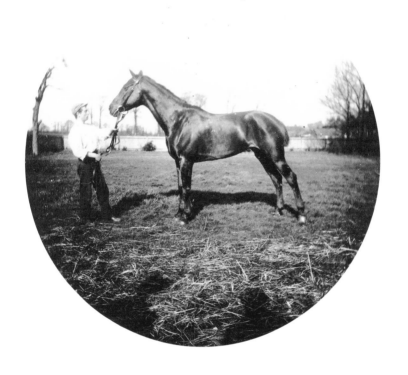

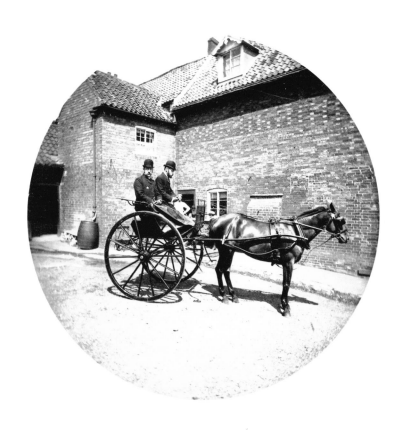

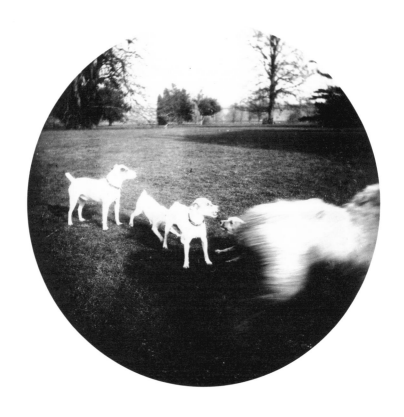

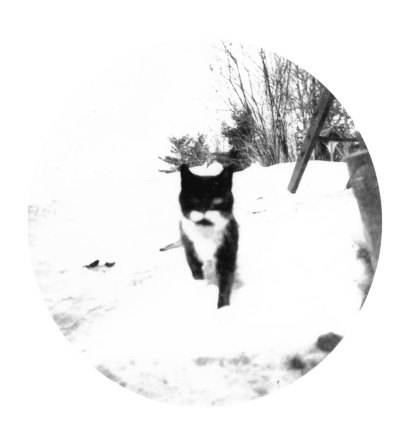

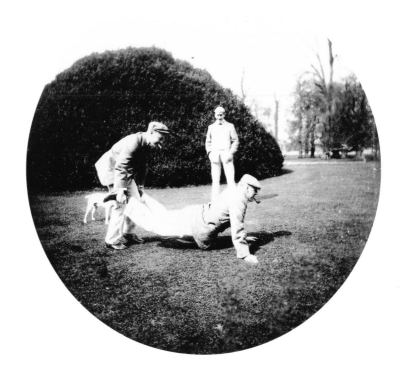

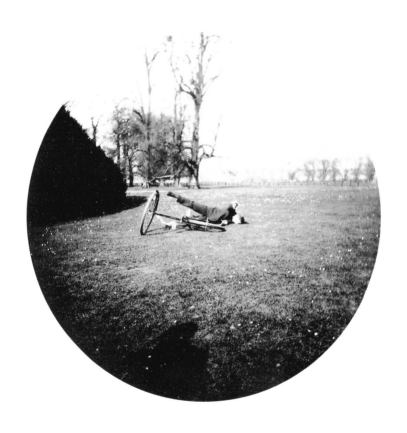

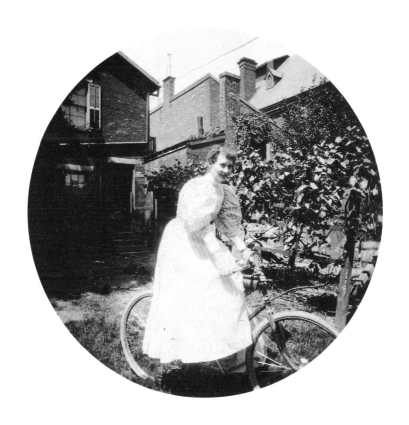

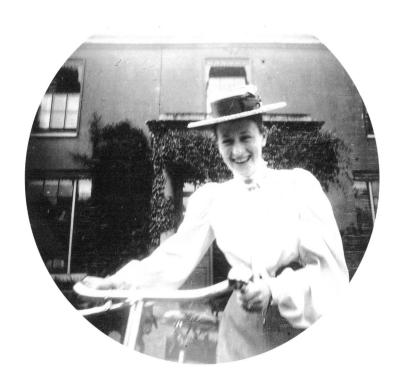

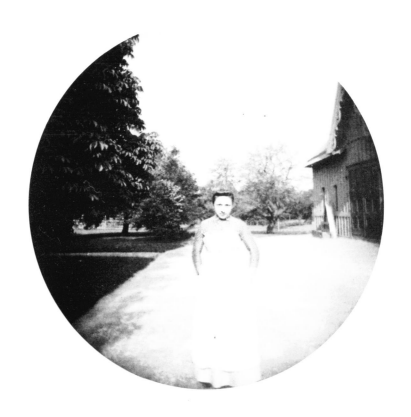

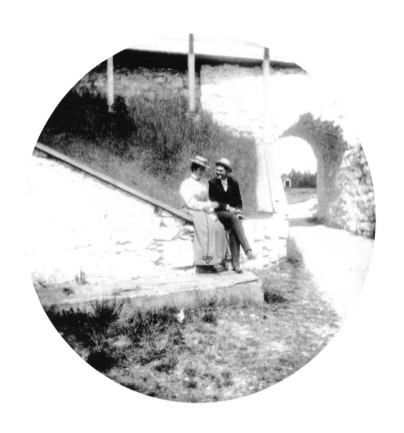

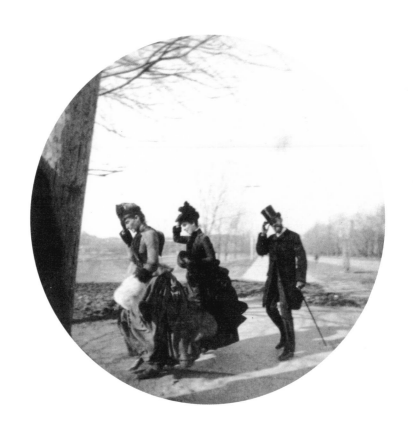

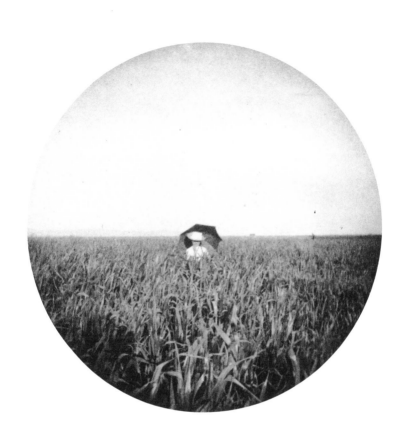

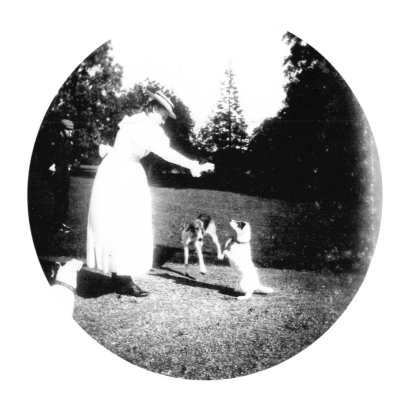

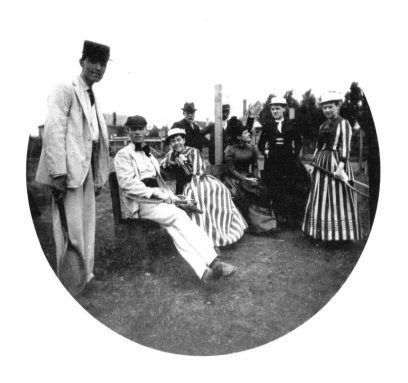

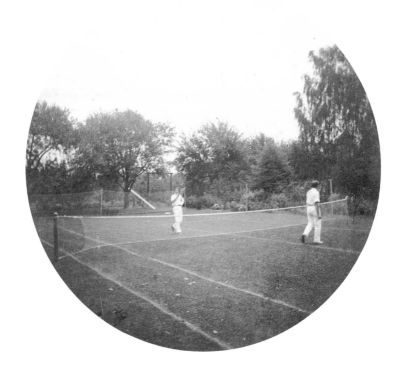

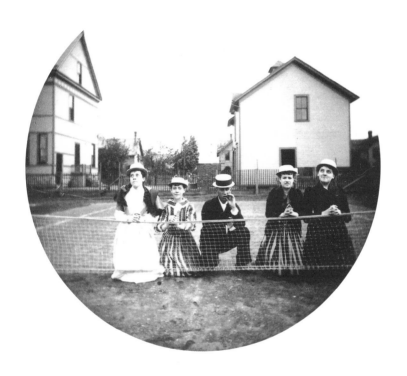

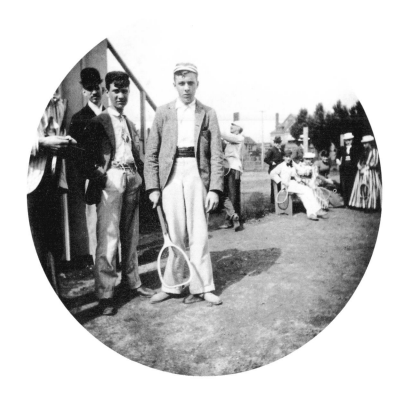

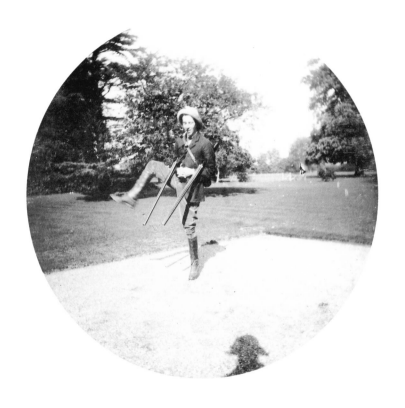

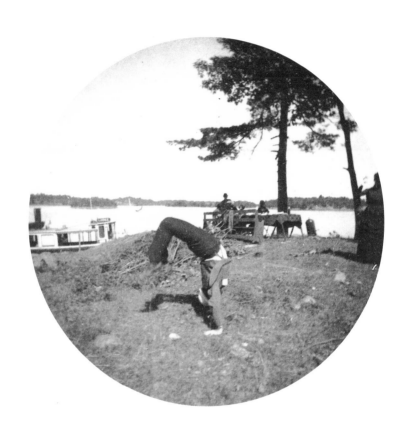

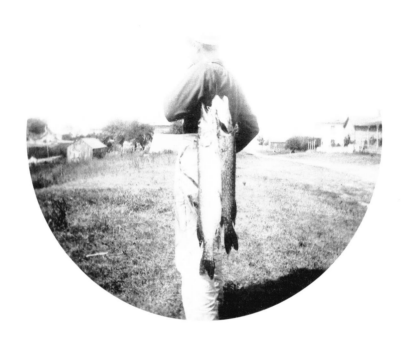

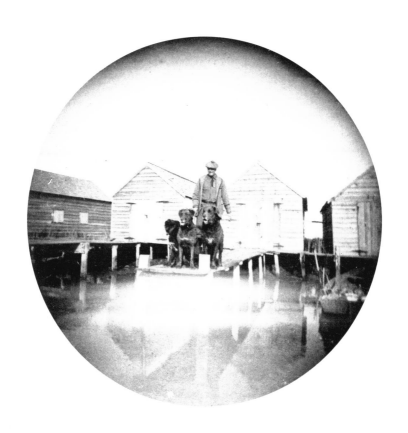

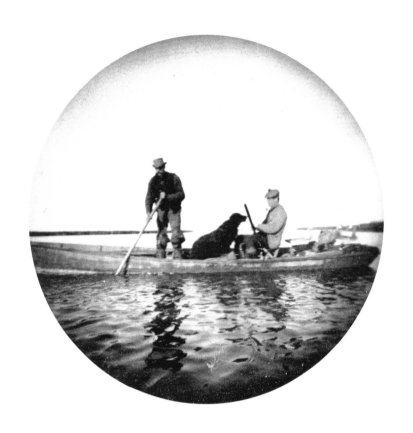

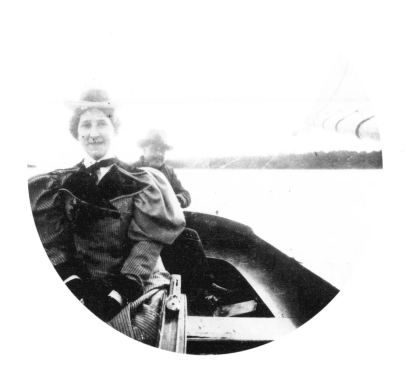

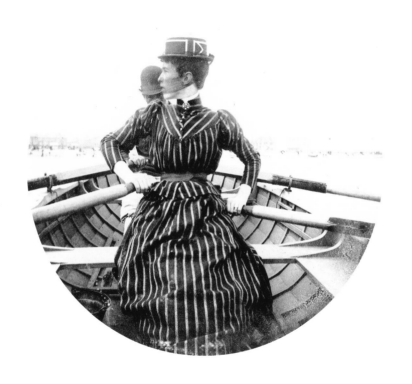

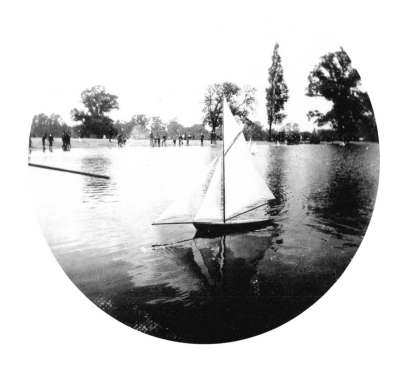

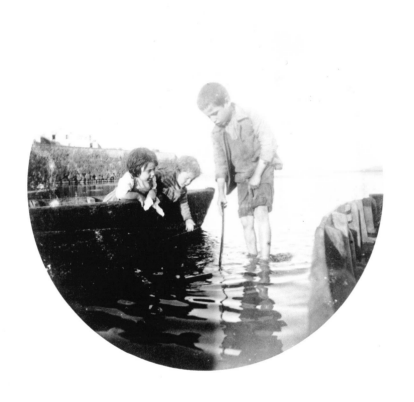

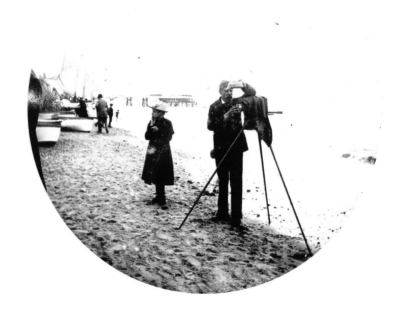

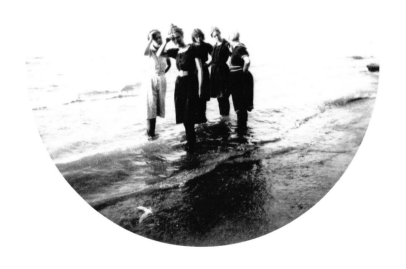

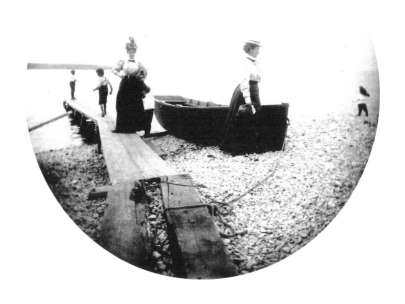

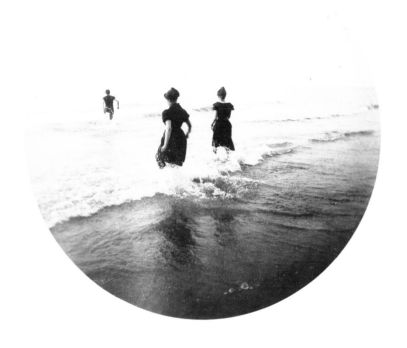

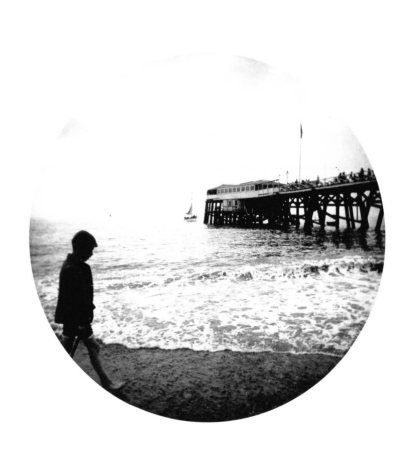

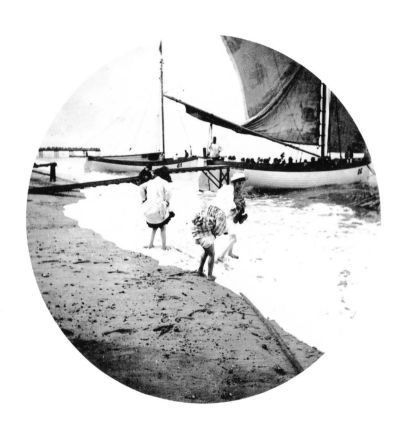

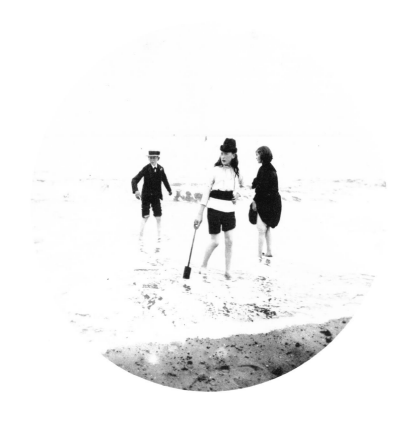

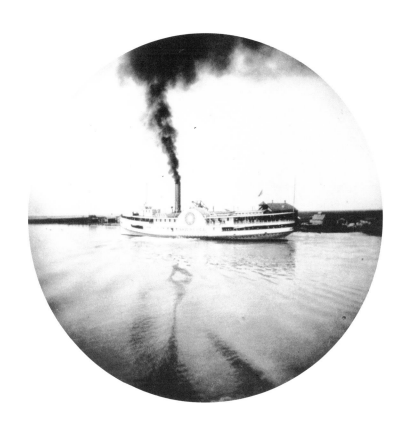

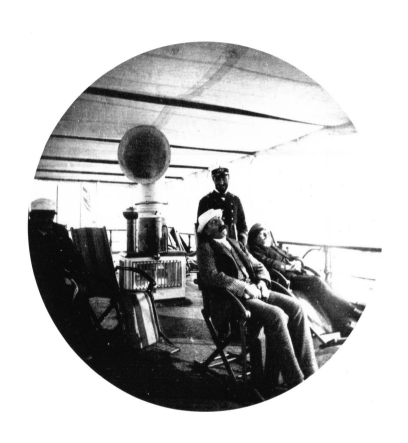

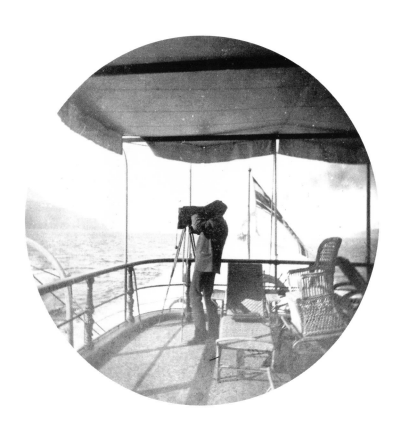

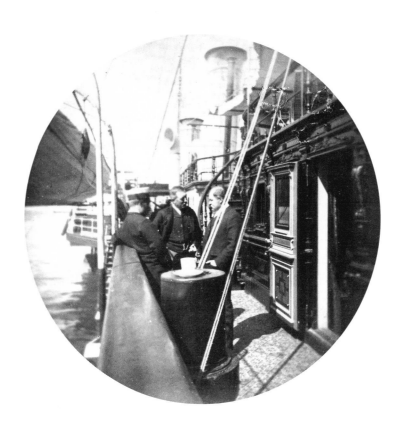

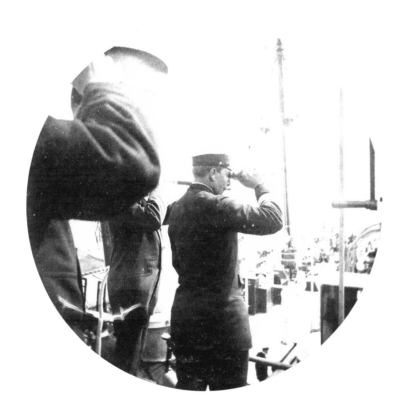

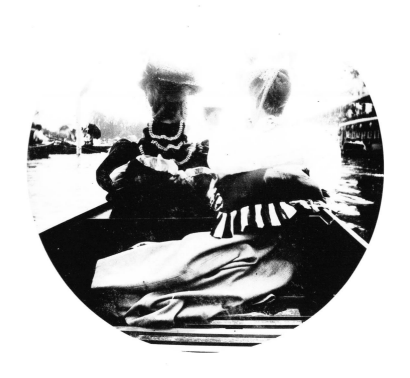

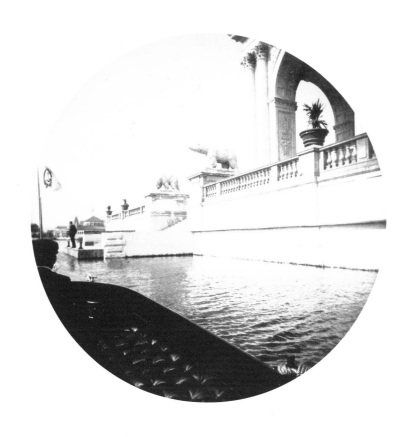

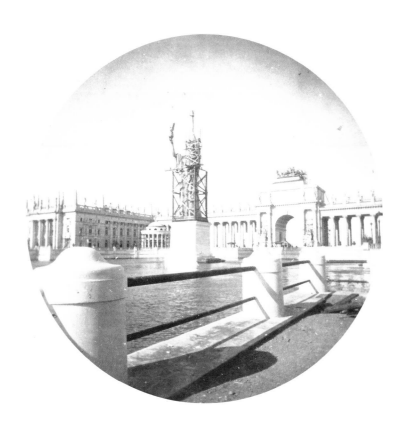

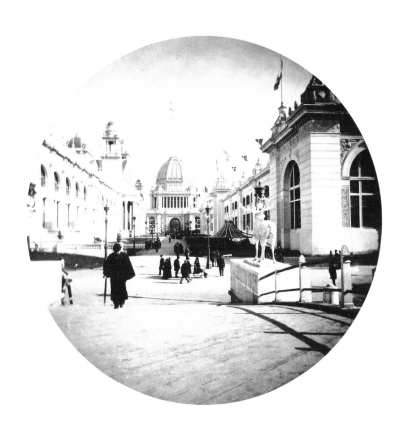

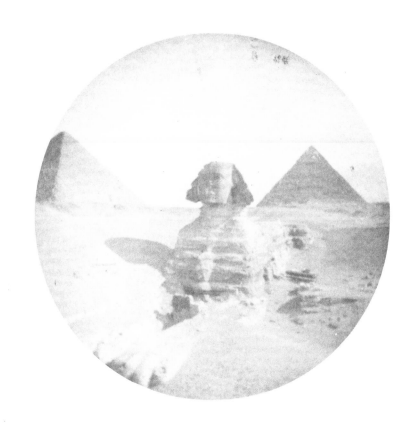

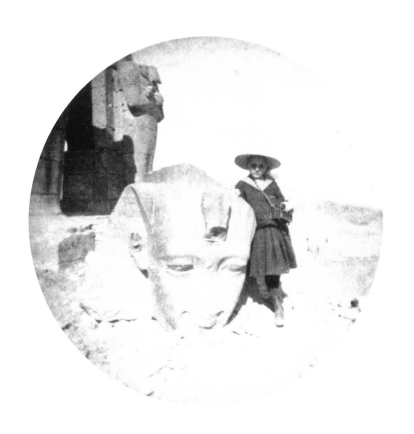

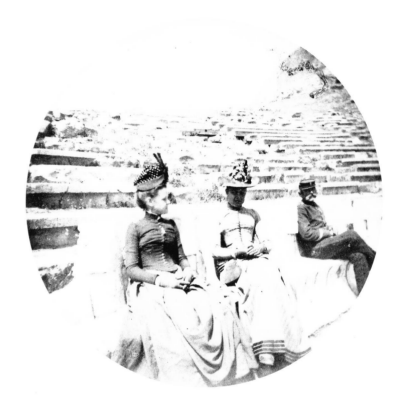

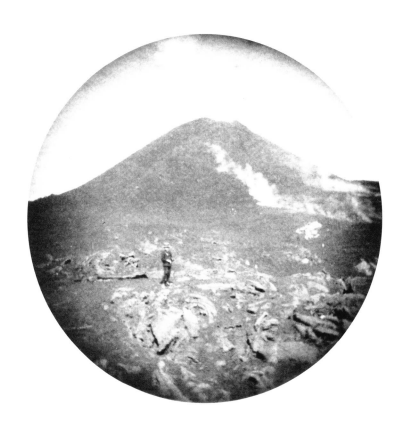

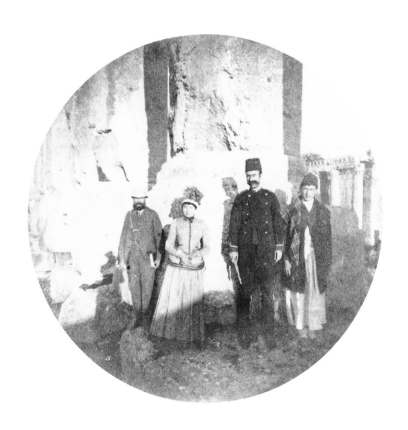

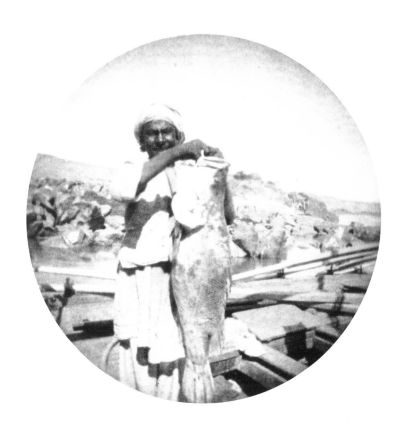

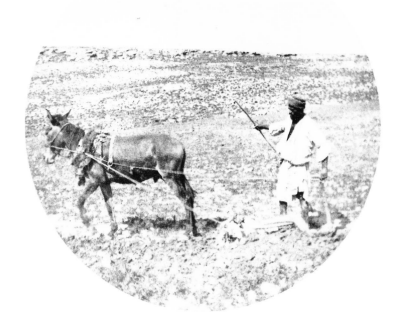

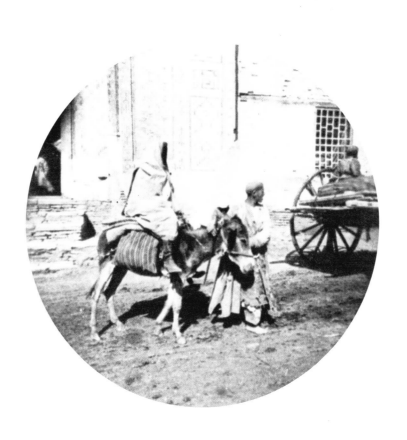

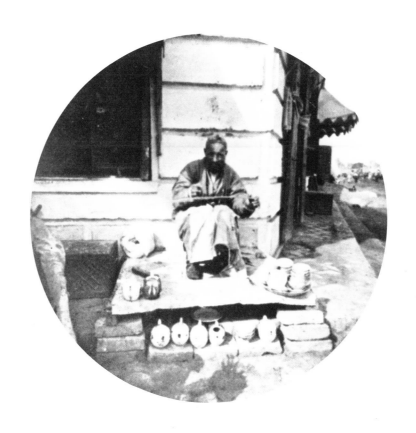

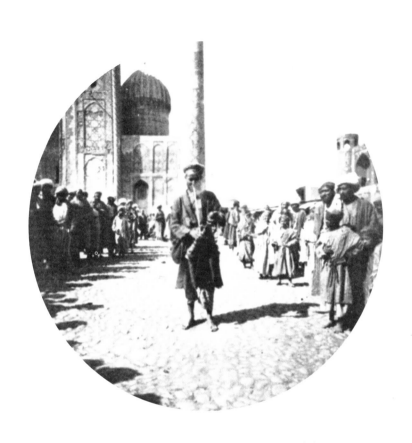

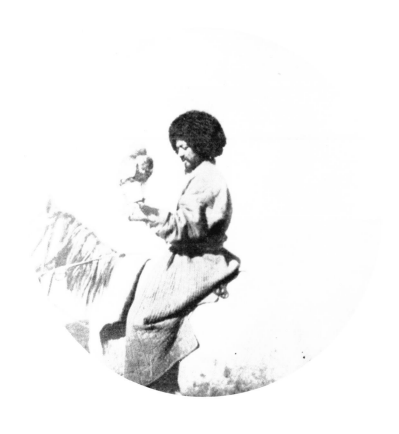

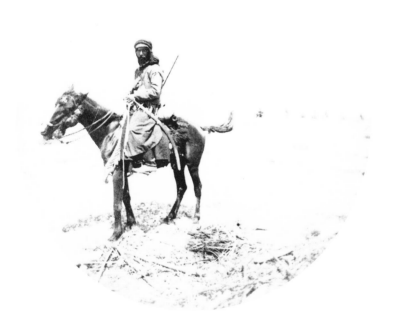

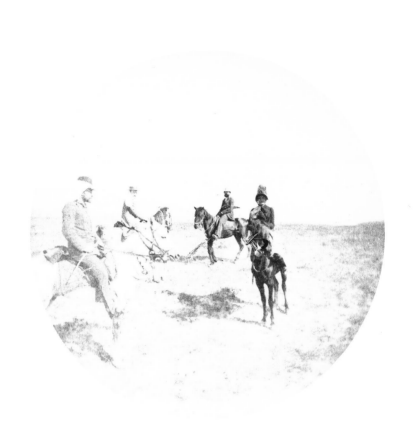

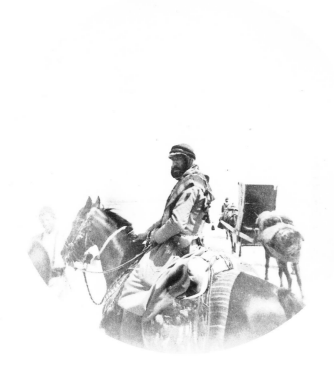

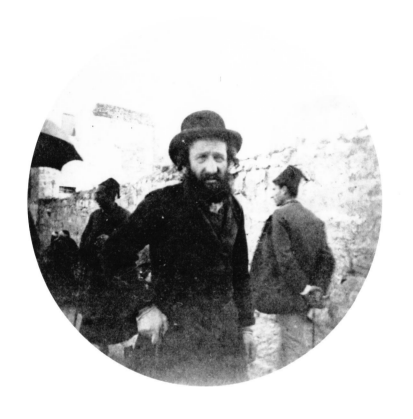

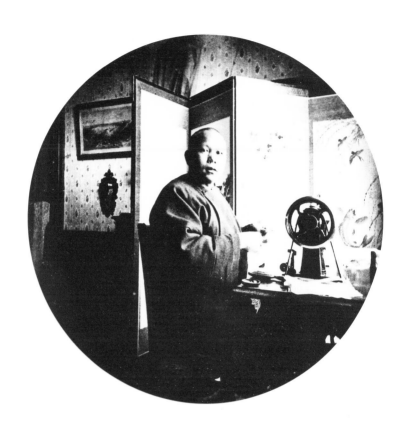

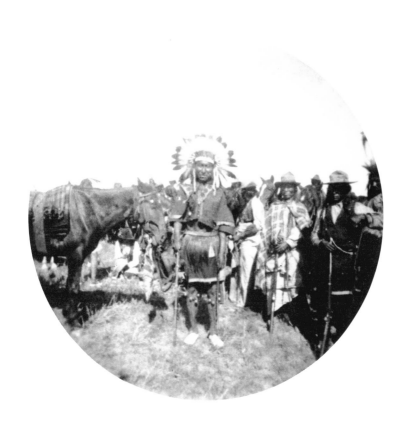

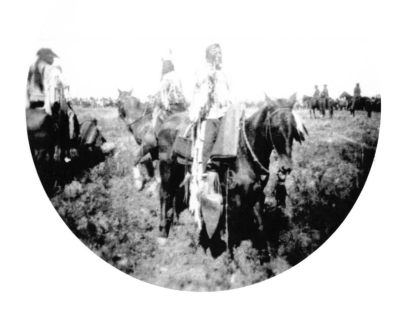

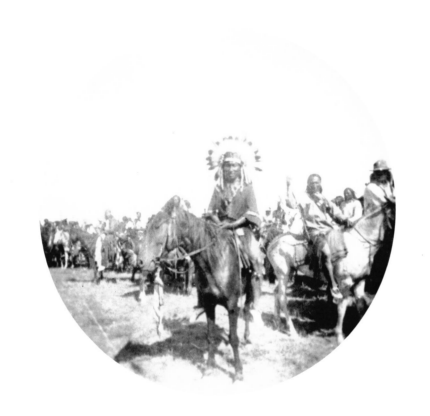

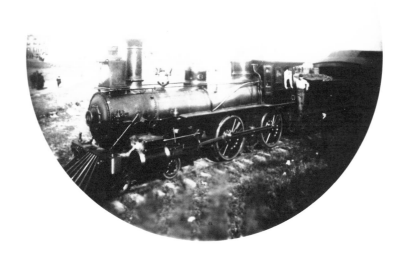

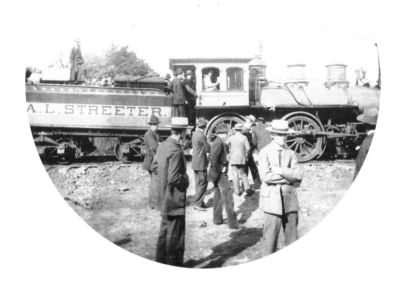

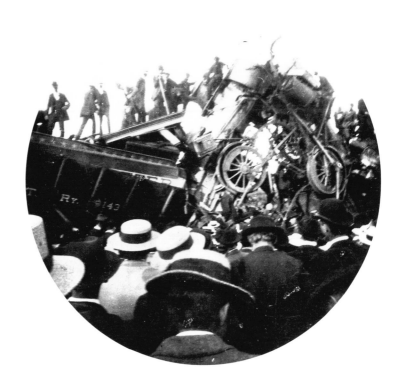

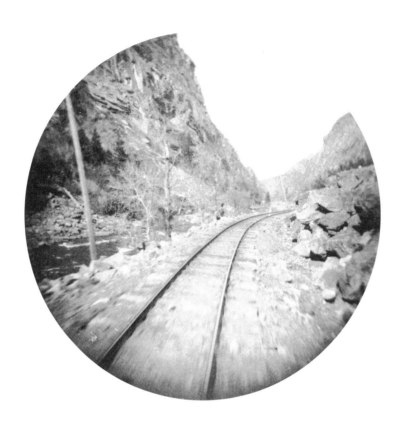

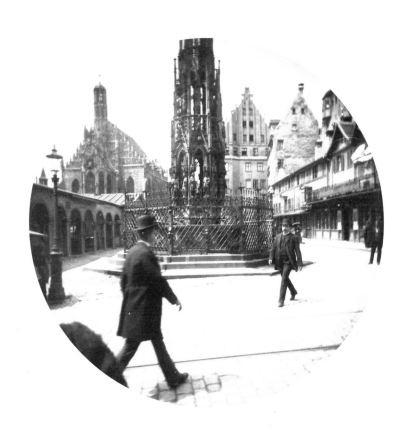

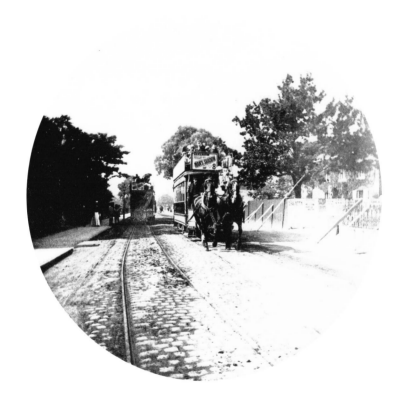

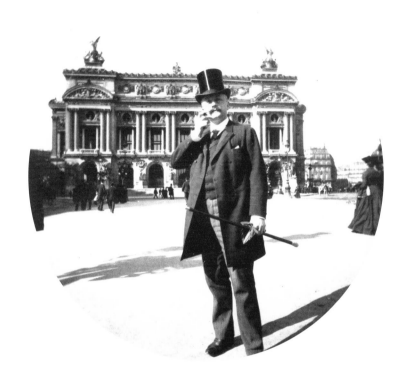

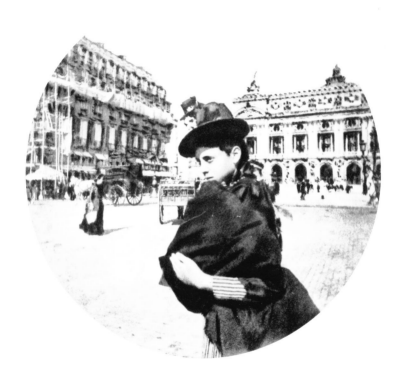

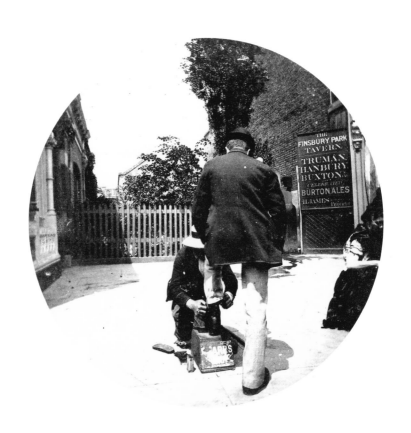

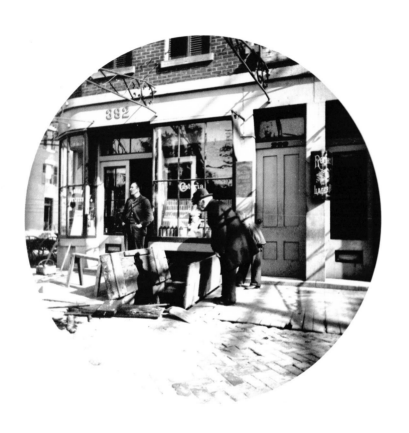

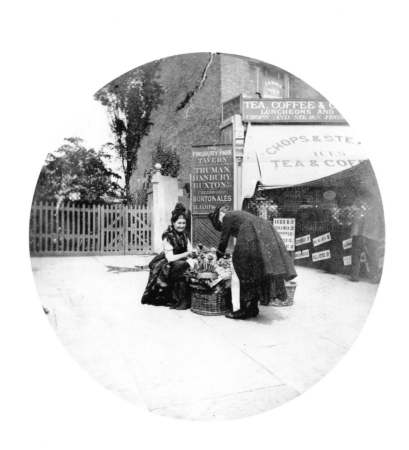

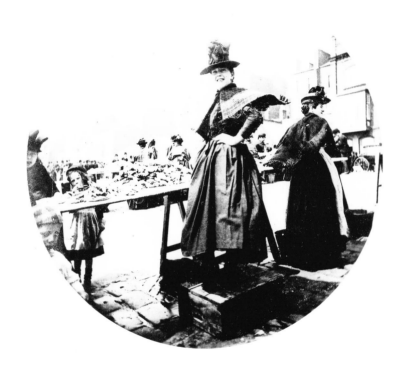

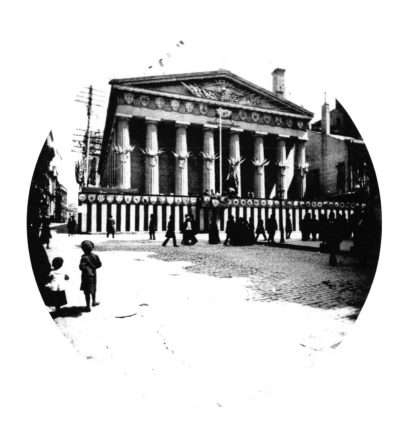

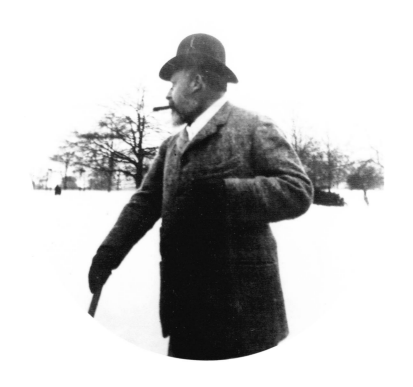

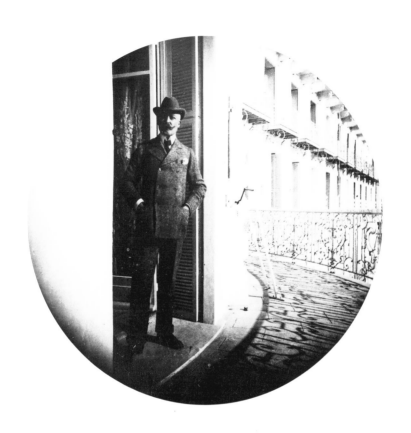

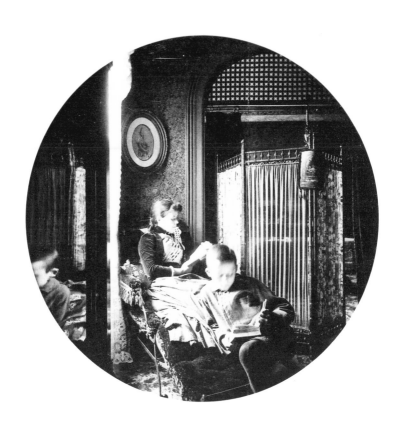

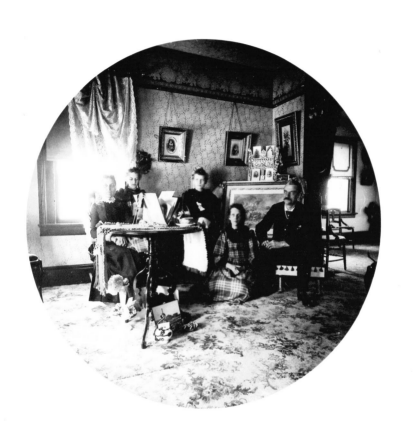

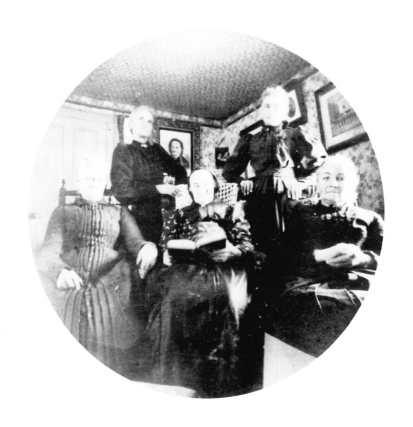

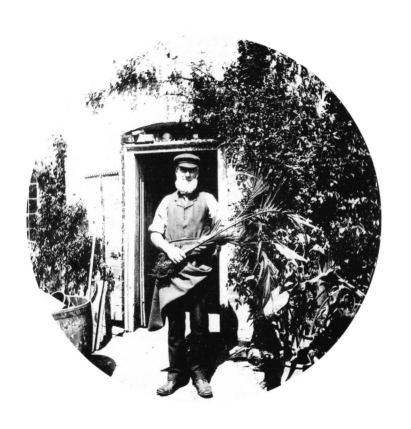

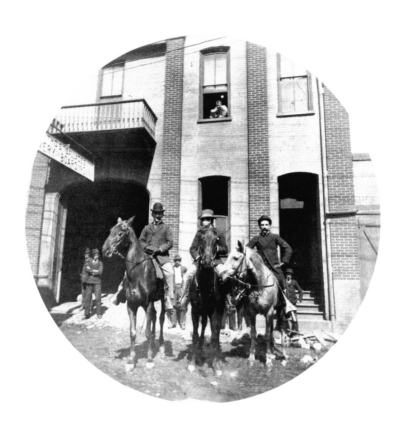

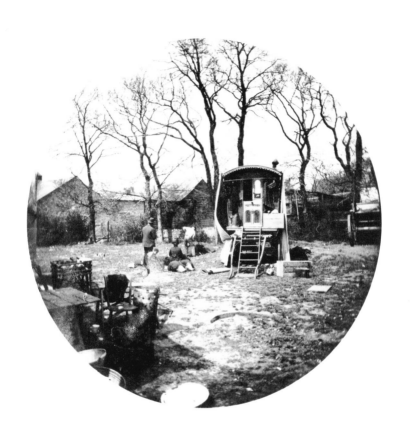

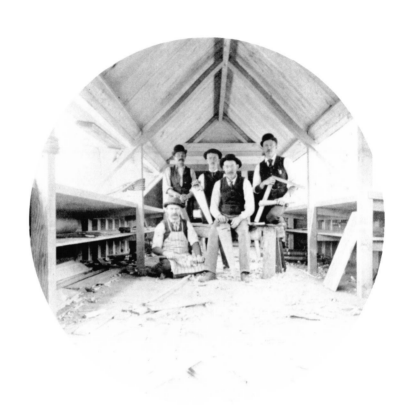

# ...We Do The Rest

# Annotations to the photographs

*page 88, 89, 90, 91:* Emperor Wilhelm was photographed on the imperial yacht 'Hohenzollern' in July 1881 with the Kodak.

*page 103, 104, 105, 106:* From a journey to Russia in 1890 Paul Nadar brought back several pictures taken with the Kodak. This trip took him to Turkestan, where the Emir of Bukhara arranged a falcon hunt in his honour.

*page 112:* Robert Wilson Redford (1867 - 1951), Chinese tailor, Victoria British Columbia, 1889

*page 113:* This picture was taken by Gilberto Ferrez.

*page 122:* George Eastman took this picture of the famous French photographer Nadar (with the Opera House in Paris in the background), when he visited Nadar in March 1890. Later Nadar and his son Paul undertook the distribution of Kodak films and cameras in France.

*page 123:* Paul Nadar(1856 - 1939), Young girl at the Place de l'Opéra, Paris.

*page 130:* Edward, Prince of Wales, at an ice hockey game, Sandringham, 1895.

*page 131:* Arthur, Duke of Connaught, on vacation, 1897.

*page 138:* The rush on the picture factory was so great, that it was necessary to build an extension. After the completion of the enlarged printing room, the carpenters pose for a photograph.

# Acknowledgement

The National Museum of Photography, Film and Television and the Kodak Limited (who's archives provided many pictures for this book) and Dirk Nishen Publishing would like to thank the following institutions and collectors for their help:

Photographic Collection Royal Archives, Windsor

International Museum of Photography at George Eastman House, Rochester, New York

Public Archives, Canada

Kodak Limited

Völkerkundemuseum Basel

Collection Robert Lebeck, Hamburg

Kodak Collection Ruud C. Hoff, Amsterdam

# Hubertus von Amelunxen

## William Henry Fox Talbot
## TIME REPRIEVED, TIME RETRIEVED
## The Invention of Photography

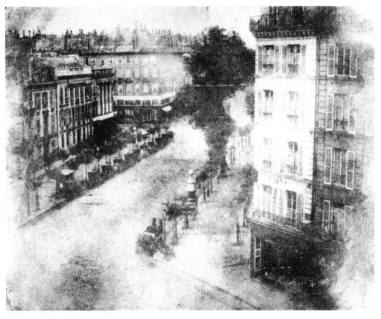

With an essay by Mike Gray
160 pages · 150 calotypes · colour · tritone and duotone printing on specially made paper
(150 gramm), hardcover, 310 x 250 mm · app. £ 30
ISBN 1 85378 005 7 · To be published in December 1988